May these verses richly bless you.

Joyce M. Bell

VERSES TO THE KING OF KINGS

Joyce Bell

CROSSBOOKS
PUBLISHING

CrossBooks™
A Division of LifeWay
1663 Liberty Drive
Bloomington, IN 47403
www.crossbooks.com
Phone: 1-866-879-0502

Scripture taken from the HOLY BIBLE, TODAY'S NEW
INTERNATIONAL VERSION®. Copyright © 2001, 2005 by Biblica®.
Used by permission of Biblica®. All rights reserved worldwide.

First published by CrossBooks 07/05/2011

ISBN: 978-1-4627-0508-5 (sc)
ISBN: 978-1-4627-0509-2 (hc)

Library of Congress Control Number: 2011932780

Printed in the United States of America

This book is printed on acid-free paper.

Any people depicted in stock imagery provided by Thinkstock are models,
and such images are being used for illustrative purposes only.

Certain stock imagery © Thinkstock.

CONTENTS

PREFACE

After retiring from teaching, I began writing and sharing Christian poems. A variety have been printed in church newsletters and often included in messages when I speak to congregations and small groups. Psalm 45:1 (New American Standard Bible), captures my reason for publishing with this title, "Verses To The King Of Kings",

> "My heart overflows with a good theme;
> I address my verses to the King;
> My tongue is the pen of a ready writer."

With great joy, I give thanks for the guidance and vision of my Creative Agent, the Holy Spirit, Who made it possible to proclaim the message of the Cross.

I am grateful for the encouragement of family and friends, especially for my husband Don's loving support. Thanks also to artist Dennis Smith (LaSalle ON Canada), to cousin photographers Alan and Janet Arseneault (McGregor ON Canada) and to computer support Todd Beneteau (Lakeshore ON Canada).

CHRISTMAS POEMS

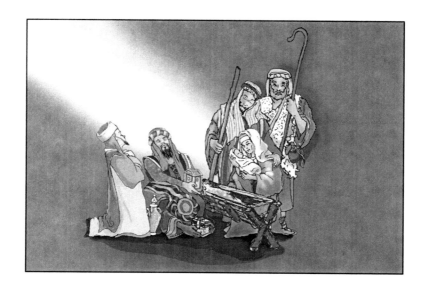

PROPHECY FULFILLED

Great prophets God did raise,
warning Israel of judgment days,
promising a Messenger for them
to lead all from their lives of sin.
His chosen people turned deaf ears
so God was silent four hundred years.
The centuries passed, all was not well
as over Israel, a thick veil fell.
First a Greek then a Roman invasion,
the Israelites were an oppressed nation.

Each generation hoped to be the one
when their Redeemer King would come,
as God, His promise would fulfill.
Then one cold winter night so still,
in a manger, a Baby gave a soft cry.
Simple shepherds in fields nearby
heard an angel's voice ring clear,
"Your long awaited Saviour is here.
I bring you Good News of great joy,
in David's town, go seek this Boy!"

A MIRACLE BIRTH

Over two thousand years ago
the whole world watched Rome
as her spectacular empire was so vast
and vicious with political intrigue,
rampant immorality and racial tension.
The land of Israel struggled
under Rome's cruel military might.
A greedy and cynical Caesar Augustus
ordered a census of his entire empire
in order to increase his subjects' taxes.
No matter how far away it was,
they had to return to their own towns
to register for this burdensome census.

A young, virgin, Jewish woman,
loved the Lord God and His Word.
When the angel Gabriel appeared
and told Mary she would give birth
to the Promised Messiah, through
the Holy Spirit's supernatural conception,
she totally surrendered her life to God.
For the census, Joseph and a pregnant Mary
were forced to make a long, difficult journey
from Nazareth, in order to be counted.
In a tiny, obscure village of Bethlehem,
God arrived, unannounced, on sweet straw,
in a lowly and cold stable's manger and then
angels gloriously proclaimed Jesus' birth.
Both our history and our eternity
hinge on this prophesied Bethlehem birth
as into our sin filled earthly world,
our Saviour and Redeemer humbly entered
because He so loves each of us.

A miracle birth indeed. *Alleluia!*

IN BETHLEHEM

David's little town of Bethlehem
was over burdened with mankind,
as many flocked here to register
in a census for Augustus, the Emperor.

In a distance from a noisy inn
of tired parents and children,
a mother nursed her firstborn child
born in a stable cold and crude.

This night, the air was warmed
by the breath of burro and oxen.
Mary held her precious baby Boy
as angels chorused with glorious joy.

She laid Him in a manger stall,
God's promised Gift to us all.
Jesus Christ was born that day,
the Prince in Person, the Messiah.

THE MESSIAH IS BORN

One dark and lonely night,
as humble shepherds in the fields,
kept watch over their flocks,
they were filled with great fear
as an angel of the Lord appeared
and a brilliant, glorious light
shone all around these men.

Then a company of heavenly hosts
joined the angel praising God,
inviting the shepherds to quickly
go and find this Lamb of God,
the anticipated Saviour,
who would take away the sins
of the whole world, forever.

The shepherds' fear turned to joy
as they left their flocks behind
to go seek the promised Messiah.
There, in a dark and dirty stable,
they found the newborn Boy,
securely wrapped in strips of cloth,
lying in a feeding trough or manger.
Joyfully they returned to their flocks,
glorifying and praising the Lord God
and spreading the Good News of
Christ's birth to all who would hear.
Later, guided by a brilliant star,
Wise Men or Magi came from the far east,
with gifts to worship this Holy Child.

The Promised One had come!

CHRIST IN A CRADLE

A Baby born as no other;
a Baby born to a virgin mother.

When angels sang of His birth divine,
shepherds quickly ran to find,
He, Who came to offer salvation,
to every person in every nation.

Wise men came from lands afar,
found this Child, guided by a star;
precious gifts they offered Him,
bowing down to the One without sin.

Rejoice! Rejoice! Come to the stable,
to worship and praise Christ in a cradle.

WISE, WISE MEN

Wise men once traveled from afar
as they followed a brilliant star,
through heat and cold, rain and snow,
over mountain tops to valleys below.
They left all they valued behind them,
families, fortunes and their friends.
After a long journey, finally,
they found the little family
and were overcome with great joy,
bowing to worship the little Boy.
Gifts of gold and perfume for perfection
and myrrh for later burial preparation.
Brutal King Herod pressured them
to find where the Child was, for him.
Not Herod, but God, they chose to obey
and returned home a different way.
Wise, wise men, we all must agree,
for the Boy's future lay at Calvary.

HIS GIFT

Come with our praises
and come with great joy.
Come to the stable
to worship this Boy.

Rejoice and adore Him,
the Gift of God's Son,
hope from a virgin's womb,
a Gift for each one.

From Bethlehem's crib
to Calvary's cruel cross,
Jesus came to save us,
the sick and the lost.

So, come to the stable
to worship this Boy.
Come with our praises
and come with great joy.

GOD INCARNATE

Our Creator so loved us,
His Spirit came to earth,
wrapped in human flesh
as a virgin gave Him birth.

In the town of Bethlehem,
a Boy was born in a stable,
bound in swaddling clothes,
rocked in a manger cradle.

All who flocked here to see,
stayed to worship Him,
the Saviour who was born
to save mankind from sin.

To the stable, to the cradle,
to the cross, now come,
bow down and adore Him.
Jesus, God's begotten Son.

IMMANUEL (GOD WITH US)

His conception by the Holy Spirit
and the virgin birth of Jesus,
are truly supernatural events
beyond our human comprehension.
The Lord God sent angels to help
Mary, Joseph, shepherds and Magi
understand what was happening.

Leaving His heavenly home
Jesus put on human flesh.
He was divinity in a womb,
taking on human limitations
so He could live and die
for the world's salvation from
the power and penalty of sin.

From a lowly manger to a cross,
from Bethlehem to Calvary,
fully human and fully God,
a Carpenter and a King,
a Servant and our Saviour,
Jesus, God's sinless Son, was born
to be the crucified and risen One.

A MESSIAH IN THE MAKING

What really was the time of the year
that Jesus was born, the One we revere,
at the autumn harvest or winter cold,
in Bethlehem, as prophet Micah foretold?

When shepherds witnessed the angels' glory,
with receptive hearts and believing their story,
leaving their fields and flocks behind,
rushed to town, their Immanuel to find.

Salvation would lie in a stable's manger
as Omnipotent became an infant in danger.
Following a star, wise men came to see
where this King of the Jews' birth could be.

Herod wanted to know what they found
but, warned in a dream, these Magi left town.
Then Herod knew he had been deceived
in his evil plot to find where this infant lived.

In this latter year of Herod's brutal reign,
he had Bethlehem's males, under two years, slain.
As Jeremiah had prophesied this mass killing,
in Ramah there was great mourning and wailing.

Because of an angel's warning dream,
to Egypt, Joseph's family safely fled the scene.
Back to Nazareth, they would later return
where this young Boy could live and learn.

A Messiah in the making!

INCARNATION AND
RESURRECTION

Jesus' life on earth was framed

by two different miracles,

from His divine incarnation

to His miraculous resurrection.

The first miracle took place

when He was formed by God's Spirit

in a young Jewish virgin's womb

and born in a crude Bethlehem stable.

A second miracle took place

when He was sacrificially crucified

then rose from the grave as our Saviour

and left His empty Jerusalem tomb.

Now let us celebrate this miracle

of Jesus' birth as it prepares us

for the miracle of His resurrection

and for the miracle of our salvation.

EASTER POEMS

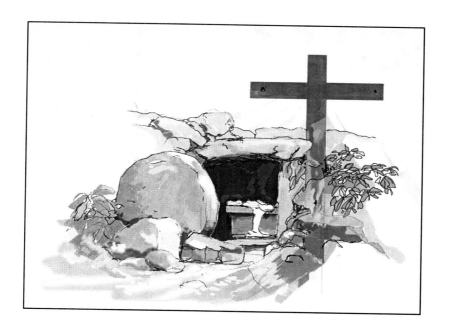

ACCEPTED THEN REJECTED

The crowds burst into joyful praise, crying out,
"Blessed is He who comes in the name
of the Lord! Hosanna in the highest!" *1

Zechariah's prophecy was fulfilled,
"Rejoice greatly O daughter of Zion!
Shout, daughter of Jerusalem.
Behold, your King comes to you,
Righteous, with salvation, gentle
And riding on the foal of a donkey."

This glorious day they called Him King,
shouting praises and buffering the rocky road
with their coats and palm branches.
But only days later they would reject the Saviour,
turning on Him and crowning Christ with thorns
and crying out for His crucifixion.

As He triumphantly entered Jerusalem,
Jesus wept over it, for the sins of the people
and for the future sorrows of the city and nation Israel.
Years later this city would be destroyed,
the temple leveled and its people massacred.
First, He must suffer for them.

*1 All four gospels TNIV

NO GREATER LOVE

How could You Lord

face the betrayal of Judas,
for thirty pieces of silver?

accept how Your disciples,
deserted and disowned You?

silently submit to immoral
and to illegal trials?

tolerate lies of tax evasion,
treason and terrorism?

endure the pain of being struck,
slapped and whipped?

accept the jeers as You staggered
under Your heavy load?

be cruelly nailed to a cross
in a shameful execution?

take on the sins of the world
and be separated from Him?

offer Yourself as the spotless
sacrificial Lamb of God?

love us enough to pay the penalty
for our eternal salvation ?

Thank You Lord Jesus.

FOR US – HE BORE A CROSS
TO WEAR A CROWN

Such terrible pain He withstood
as nails forced flesh to wood.
In pain, the cross groaned,
in shock, the earth quaked.
In shame, the sun veiled its light,
as day become as dark as night.
In sorrow, the women cried,
by men, God's Son was crucified.

All heaven and earth then praised,
on the third day Christ was raised.
The sun welcomed Easter morn,
a new and glorious day was born.
The grave's stone rolled aside,
the tomb gave up He who died.
Angels were waiting there to say,
"He is not here, He has risen today."

Hallelujah! The King reigns forever!

CHRIST IS CRUCIFIED

Three metal spikes
were nailed into Him,
but never broke a bone
of the One without sin.

At the cross the women wept
as Christ our Saviour bled.
The stormy sky turned black;
the ground below stained red.

From top to its bottom
the temple's veil was torn.
The angry earth quaked
as all of nature mourned.

Holy bodies walked the earth
as their tombs opened wide.
These miracles all happened
when Christ for us was crucified.

Resurrection Day was on its way!

CHRIST IS RISEN

Just after sunrise,
when the Sabbath was over,
three women came to His tomb
with anointing spices and perfume.

The earth began to tremble,
the grave's seal was broken.
The entrance stone rolled away
as guarding soldiers prostrate lay.

Two angels dispelled all gloom,
" Fear not; He is not here.
Go quickly and tell the others
in Galilee He will appear."

Mary Magdalene was blinded by grief
until Jesus spoke her name,
then she knew no rock or guard
could stop His eternal reign.

But behind locked doors,
hiding with terrible fears,
these women's joyful news
fell on the disciples' deaf ears.

Then Peter and John ran to see
and stepped inside the tomb,
His grave clothes laid intact,
shaped like an empty cocoon.

Confused, the two men walked away
but Jesus revealed His glory that day.
Finding the others, they joyfully said,
"It is true! The Lord is not dead!"

Christ is risen! Alleluia!

AND THE ANGELS ALL SANG

Jesus could have called on the angels
to rescue Him from the cruel cross.

Thousands of them would have come
but He refused to call for their help,
so Jesus died alone, to take sin's penalty,
for you, for me, all of mankind, for all time,
as the angels veiled their faces in sorrow.

They just couldn't bear to silently watch
this sinless Son, obedient Lamb of God, sacrificed.

Suddenly the darkness of crucifixion day
was shattered by the Light of salvation
with the miracle of Jesus' resurrection.
Heaven was electrified with divine music
as millions of angels chorused to the Risen One.

Then an angel left this Heavenly party
and descended to earth on a mission.

He was as bright as lightning and
his clothing dazzled white as new snow.
Touching down on the earth, it quaked,
and with ease, he rolled back the huge stone,
sealed in place at the entrance of Jesus' tomb.

Armed Roman guards shook and keeled over,
totally paralyzed with a terrible fear.

Jesus had already risen from the grave,
He had defeated death, as He promised.
Now His followers could enter in and
see for themselves that the tomb was empty;
and the angels all sang of the Risen One.

BECAUSE HE LOVES US

Son of man

arrested by temple guards where He had come to pray
kissed by a traitor on the eve of His last earthly day

Lord of truth

abandoned by His friends and even disowned by Peter
tried unjustly six times by Jewish and Roman leaders

King of kings

mocked with a royal robe and a cruel crown of thorns
taunted with Hail, King of the Jews, fulfilling why He was born

Prince of peace

spat on and struck by many and accused of terrible crimes
soldiers' whips with ends of metal wounded Him time after time

Lamb of God

forced to carry His own cross to Calvary's fateful hillside
beloved John and Mary were there when, for us, He was crucified

Son of God

rose from His earthly grave in His promised resurrection
appeared to commission His faithful before they witnessed His ascension
Because He loves us!

OUR RISEN AND REIGNING SAVIOUR

Judas betrayed Jesus with a kiss of death.
Jealous religious leaders falsely accused Him.
His disciples were afraid to come to His defense;
Peter denied his Lord three times.
Jesus stood silent before His accusers.
The crowd called for Barabbas' release;
they shouted aloud for Jesus' death.
Pilate bowed to the crowd's demand.
Soldiers mocked and struck Him;
Jesus was cruelly whipped and crucified.
Friends buried Him in a new tomb.
Darkness covered all the land.
The temple curtain ripped apart.
The earth quaked and rocks split open.
Graves spilled out their dead;
Holy people were raised to life.
Jesus' tomb could not hold Him;
He was raised on the third day.
Death and Satan were defeated.
Hundreds of witnesses saw the Risen Lord;
they knew their Saviour was alive.
He lives and reigns today in all believers' hearts.

WE WERE ON HIS MIND

We were on His mind
that triumphant Palm Sunday
when Jesus entered the Holy City and
during the Last Supper as He blessed
His disciples and washed their feet.

We were on His mind
later on in Gethsemane's dark garden
where He passionately prayed to God and
when Judas' kiss betrayed the Christ
and Roman soldiers arrested Him.

We were on His mind
as through the clamoring, crowded streets
He struggled to carry a heavy cross to
outside Jerusalem's city gates
where He was cruelly crucified.

We were on His mind
as He died for all mankind's sins
and for our eternal life with Him
when He rose victoriously from the grave
on that glorious, joyous Easter morning.

We were on His mind
when He sat at the right hand of God
to be our loving, eternal intercessor and
He sent His Comforter, the Holy Spirit
To live in us forever and ever.

We are always on His mind.
Is He forever on our mind?

PAID IN FULL

Look up at the sign
fastened to a cross,
"Jesus Of Nazareth
The King Of The Jews."
Watch the crimson blood
of our nail pierced Saviour
spread down the splintered wood
to the trampled earth below.

Hear the mocking guards
dividing His garments,
casting lots for a seamless one.
Listen to the raucous crowd,
along with their sneering rulers,
hurling insults at Him and
two crucified robbers insulting Him
until one believes and repents.

Share the agony of brave followers
with Mary, Jesus' beloved mother
and John, His faithful disciple,
watching and weeping at a distance.
Tremble as all nature mourns
with darkness then earth quaking,
when Jesus, with His last breath,
commits His Spirit to his Father.

Rejoice, believers, Jesus has paid
the full price for all sins!
Rejoice for Resurrection Day
would soon be on its way!

HIS LOVE WAS ENOUGH

God sent Heaven's Best

for the earth's worst.

His love was enough for

Satan's chains to burst.

Jesus came to earth to

seek and save the lost.

His love was enough,

no matter what it cost.

Nails weren't needed to

hang Him on that tree.

His love was enough to

hold Him for you and me.

He was the perfect sacrifice

to set us free from sin.

His love was enough

for all to be forgiven.

WHAT WOULD WE HAVE DONE?

Judas Iscariot betrayed Jesus.
Religious leaders arrested Him.
Peter denied Him three times.
His disciples deserted Him.
The crowds shouted, "Crucify Him."
Pilate bowed to their demands.
Soldiers mocked and beat Him.
Simon of Cyrene carried His cross.
Roman soldiers crucified Jesus.
Passerbys hurled insults at Him.
Two crucified thieves reviled Him.
One thief repented before his death.
Several women watched in horror.
A centurion praised God for Jesus.
Joseph and Nicodemus buried Him.
Angels proclaimed to the women,
"He has risen!"

What would we have done?

THE SISTERHOOD OF CHRIST

His beloved mother Mary
was first at His cradle
and the last at His cross.

His dear friend Mary
sensing His imminent death,
in a loving tribute,
poured costly perfume on Him,
then, with her hair, wiped His feet.

Mary Magdalene with other women
witnessed His crucifixion and burial.
Angels announced to them first
that Jesus had risen from the dead
and they were to spread this Good News.

Although these same women
couldn't speak out in His defense,
stand up against the crowds
or overpower the Roman guards,
they did what they could.
They stayed at His cross
when the disciples had fled
and followed Him to the tomb
with anointing spices and perfume
as their sign of love and respect.

I F

If a tree could talk,
would it praise the Creator
for the sun's warm rays
and the clouds cool rains?

If a tree could talk,
would it wonder aloud
what its fate would be
as men cut down this tree?

If a tree could talk,
would it have understood
why the body of a cross
was formed from its wood?

If a tree could talk
would it cry out, "No!"
as a tortured Man, in shame,
is nailed to it in great pain?

If a tree could talk,
would its tears mingle
with the blood of the crucified
as it held Him close while He died?

If a tree could talk,
would it thank the Father,
for the gift of holding His Son
until His work on earth was done?

FROM RESURRECTION
TO ASCENSION

The sacrifice was made, the price for sin paid.
For the next forty days Christ walked on earth.
He had risen from the grave and His Church gave birth.

With His disciples He ate fish and bread.
They touched Him – Jesus was alive, not dead!
Now their doubts were gone – His Kingdom would come!

He promise to send His Holy Spirit with
power and conviction as He commissioned them
to fearlessly spread the Good News to every nation.

As our Saviour's mission here on earth was done,
Jesus Christ gloriously ascended to Heaven
to sit at God's right hand – forever to rule and reign.

JESUS CHRIST – LEADER, LOSER OR LORD?

Leader?

You were a humble servant, homeless and poor.
You had no army, purple robe or golden crown,
just a ragtag band of fisherman and friends.
As You magnetically drew the unschooled masses
with miracles, You fed them spiritually and bodily.
You taught them of God's Kingdom and His love.

Loser?

Knowing what fate awaited, You entered Jerusalem.
You were the perfect Lamb, a sinless sacrifice for us,
obedient to the Father, You permitted Your capture.
You were illegally tried and cruelly beaten and
as a criminal, You were executed on a crude cross.
Most of your fishermen and friends fled in fear.
You were quickly buried in a borrowed tomb.

Lord?

With glorious resurrection, You defeated death.
You triumphed victoriously over sin and Satan,
bridging the gap between God and humanity.
You are the chosen cornerstone of Your Church.
As the living Messiah, Son of God, Saviour of man,
You gave us the Holy Spirit and hope of Heaven.
You are the Leader, the Lamb and the Lord of life.

HE HAS RISEN AND HE REIGNS

Cruel and evil men had nailed Him
to Calvary's cross.

All the hosts of hell tried to hold
the crucified Christ in the sealed tomb.

But they failed. God triumphed
with victorious power.

Christ rose from the grave of mortality
to the eternal throne of our immortal God.

He is now seated at God's right hand
in the Heavenly realms.

Our Messiah reigns, Master of everything,
Head of the Church, our Saviour and King.

HIS ALTAR

Come to His altar at Calvary's tree
and from our burdens Christ will set us free.

Lift up our praise to God in Jesus' name,
Who sealed our salvation when He took away all shame.

Lay down all our sins at the foot of our King
and rise up forgiven, cleansed and redeemed.

HE PROMISED HE WOULD

All the promises of prophecy were fulfilled at Calvary
to grace us with a heavenly home.

Jesus lay down His life with His crucified body
to redeem us from our sins.

He is coming back again to gather together His children
who are faithful to His Holy Word.

No one really knows when Saviour Jesus is coming again
but it could be very soon.

In glory He will return for believers who have died
and for believers still alive.

Believe and receive His guarantee because He is coming again
as He promised He would.

COMFORT POEMS

NEW BEGINNINGS

A new beginning comes our way
as we start each new year
and awake to each new day.

A new beginning for Jesus as a baby
born in Bethlehem's lowly manger,
fulfilling Old Testament prophecy.

A new beginning for our salvation
as Jesus performed miracles and preached
to all people through the Jewish nation.

A new beginning as Jesus died,
became a cornerstone for His Church
and for all our sins He was crucified.

A new beginning as His resurrection
gives all believers hope and the promise
to live with him in eternal perfection.

A new beginning on that awesome day
when, in Him, we were born again
and began to believe and to obey.

Thank the Lord for all our new beginnings!

RIVER OF GOD

As we travel God's river of the water of life,
through times of blessings and times of strife.

Storm clouds may gather from shore to shore
as wild waters begin to foam and to roar.
Sharp rocks snag us – we're tattered and torn,
by His waves and breakers we're stripped and shorn.

Look down at the bottom littered with debris,
our old sins and hurts we will likely see.
Will we just drift along or sink deep in sin?
We can accept God's grace and with Him swim.

No matter what kind of sinner we've been,
these living Holy waters will wash us clean.
Repent of all wrongs and hold Jesus dear,
drink deep from this water – it is safe and pure.

HE NEVER LETS GO

With cords of His kindness and with ties of His love,
He will guide and bind us.

At times He will lead us as his cord will be taunt;
He will secure and protect us.
At times He will nurture and His cord will be slack;
He alone knows our future.

Do we string together all the vivid hues of joy and praise?
Or do the dark colours of worry and despair spoil our days?
Are we securely tied with His perfect timing?
Do we strain and tear away in fear and doubting?
Look to our risen Saviour and remember all His blessings.

With cords of His kindness and with ties of His love,
He will guide and bind us.

DEAR ONES

Summoning each daughter and son,

He has called us one by one.

No matter how dark our night,

God shines forth His light.

No matter how deep our pains,

Jesus forever within us reigns.

No matter how strong our fears,

our Comforter always hears.

Woven in the depths of His love,

He has redeemed us by Christ's blood.

TURNING CARES INTO PRAYERS

When
our will seems so weak
as temptations begin to triumph,

we are fearful of the future
and worry over family or work,

we are desolate with despair
or allow a grudge to grow,

we are sorrowful over our sins
and are disturbed by disbelief,

our pride grows too powerful
or we are impaired by impatience,

Turn cares into prayers.

A PRAYER FOR HEALING
AND WHOLENESS

Blood of Christ, cover and cleanse,
Lord and Master of our soul,
heal our hurts and hearts today,
heal us and made us whole.

When we disappoint one another,
our friends are unfaithful,
or our loved ones desert us,
and the secrets of our sinfulness,
the darkness of despair and doubt,
or pressures of our debts and duties,
sharply pierce and wound us,
help us to confess and repent of all sin,
to focus on and surrender humbly to You,
and to be filled by Your Holy Spirit,
to honour and praise You each day,
to know Your secure and lasting love,
and to always trust You and obey
until we are together in Heaven above.

Blood of Christ, cover and cleanse,
Lord and Master of our soul,
heal our hurts and hearts today,
heal us and make us whole.

BETRAYAL

As pleasures, power and possessions
take the place of Christ in their lives,
potent princes, presidents and prime-ministers
betray the trust and faith of their loved ones.

Betrayals down through the ages,
Eve, King David and Judas Iscariot,
we read of them in the Bible's pages.

Betrayal causes tremendous pain,
shatters, emotionally and spiritually cripples
and those wounded are never the same.

Betrayal corrupts, devastates and destroys
families, churches, communities, even nations
for sinful affairs and fleeting immoral joys.

God's Holy Spirit transforms the transgressed
with His inner healing we can be blessed.
Christ gives real victory to all over sin,
if only our hearts are open to Him.

SACRED SHELTERS

Our family can be a sacred shelter,
where we are accommodated and accepted.
It shields us in times of trouble.
It helps us deal with faults and failures.
We are nurtured.
We nurture in return.
We are trusted with doubts and dreams.
We need each other.
Our Creator made us this way.

No one person can satisfy all our needs,
nor can we satisfy all of another's needs.
We just aren't wise, patient or loving enough.
We need Christ every day, in every way.
Only God is sufficient.
We need to trust our loved ones to His care,
His unfailing love, mercy and forgiveness.
God is our Heavenly Father.
We can be sheltered in His sacred family.

FROM WOMB TO TOMB

God created you and me
because He first loved us.
Shaped in our mother's womb,
in a sacred and safe place,
He alone knew our unformed body
as we were wonderfully made.
Each person is a special seed
planted by the Great Gardener.
Jesus Christ is the vine,
and we are His branches.
We are to joyfully bear fruit
for as long as we live on earth.
Even when we are old and gray
our Rock and our Salvation,
will guide and protect all His own,
until the day Christ brings us home.
Never will He forsake us,
we are His, from womb to tomb.

GOD IS ENOUGH

When we are slapped with a slur
or a slip of the tongue
with harsh and hurtful words,
our hearts are broken,
our feeling are bruised
as we are deeply wounded.
When we are jarred and jolted
by shallow or selfish people
or earth shattering, evil events,
pray for His Spirit and strength;
be firm in our faith,
only He can heal our hurts.
There are no triumphs without trials
but a life of risks and rewards.
He has a purpose for our pain,
pray for release and relief,
for guidance and grace of His Spirit;
He is our security and self-esteem.

FOR YOU AND ME

He walked he land and He walked the sea,
He promises life to you and to me.

He blesses and heals as He sets sinners free,
He shows His love for you and for me.

Christ bore our sins on Calvary's tree.
He died for you and He died for me.

He promises forever a home in eternity,
for all believers, for you and for me.

Jesus lives today for all to see
when He lives in us, yes, in you and in me.

MEMORIES

Those memories stored and cherished forever,
the pleasant and joyful, our childhood treasure,
are carefully wrapped and gently lay
close to our hearts, always to stay.

The bitter and painful, buried in our soul,
recycled and recited, we can't let them go.
Wounds open wide, again and again
as we relive our anger, our fear or our shame.

There is a Healer, a comforting One.
His name is Jesus, God's only Son.
Trust and believe that He died for all sin,
just open your heart, let Him reign within.

WHERE TO?

We are all just passing through;
our journey may be long or brief,
crisscrossed with pain and gain,
triumphs and trials, joy and grief.

We are aliens in a foreign land,
but God gives us a map, a manual,
its His Holy Word – His Holy Bible,
for all to trust and closely follow.

At times we must break camp,
moving far off to strange places,
dealing with difficult situations,
and seeing only unfamiliar faces.

Homesick – yes, for our Heavenly haven,
His faithful children will always be,
but we know the best is yet to come,
living with Christ in eternity.

FORGIVENESS

We may be terribly harmed, damaged or violated by others;
we frequently hide the pain deep within our fragile souls.

When we do forgive those who have wronged us,
it doesn't make right the wrong that was done.

The wrongdoer so often may shun forgiveness,
refuse to talk of this pain or even admit to hurting us.

All physical ties with them may be completely severed;
a chasm of time can exist, or death has intervened.

The Holy Spirit will help us to truly forgive others,
no longer to be enslaved by bonds of hate and fear.

God forgives us our sins so we must learn to forgive;
those forgiven may repent and turn to Jesus as Lord.

TRUST HIM

His compassion never fails even when
our will is so weak and our sins overcome us
as we are burdened by guilt,
or
our family or friends forsake us or co-workers
or neighbours scorn us and we are tired of being good,
or
our parents disappear into senility, our own health may deteriorate
and we feel helpless and alone,
or
we have lost our way and no longer hear His voice
so we lose the courage to go on.

Even when we are facing times
of difficulty and discouragement,
His loving compassion never fails.
Jesus is a faithful Friend and Keeper.
Fear not! Trust him always!

His compassion never fails!

GOD LOVES US

Yes, God loves us,
He loves you and me
with an infinite love,
His children we'll always be.

No matter how we fail
or how great our sin,
when we truly repent,
we turn hearts to Him.

On the cruel rugged cross,
He made a great sacrifice,
where, for all our sin,
Jesus paid the supreme price.

With eternal mercy and grace,
He is righteous, just and kind,
so love Him with all our heart,
our soul, strength and mind.

BELIEVE AND RECEIVE

Do you feel empty?

Is something missing?

Is there a hole in your soul?

No matter how you've tried

to fill that void,

nothing has satisfied.

What can you do?

Where can you go?

Who can you turn to?

There is only One,

Who heals our heart,

it is God's beloved Son.

Jesus died, crucified,

then rose from the grave,

from all our sins to save.

God promises a Heavenly home

with all His saints and

Jesus on His throne.

Believe and receive!

LOVED ONES

Time quickly passes by

and our memories dim

of the people we've known

and the places we've been.

For those we've loved

for years and years

and with them shared

our triumphs and tears,

even distance or death,

won't part us forever,

Jesus promises believers

a Heavenly home together.

We may reminisce with

an ache in our heart

but joyful days are ahead

when we're no longer apart.

OUR SOURCE OF JOY

We are surrounded and impacted daily
with depressing, discouraging events,
filling us with worries and fears;
we become bitter, negative and joyless.
If we listen to the Apostle Paul,
imprisoned and bound in chains,
he stresses that it is not God's will
that His followers will always be healthy,
free from suffering or will even be wealthy.

It is God's will, that we believe in Jesus
as our Saviour and even suffer for Him;
He promises to be with us, to uphold us,
no matter what we must endure on this earth.
With every mountain and valley we face,
He is today and will continue to be,
our source of strength and contentment;
we can joyfully share with many others
the awesome blessing found in Christ alone.

Rejoice!

HANDLE WITH PRAYER

When fears flood us, worries wake us
or doubts depress us,
when sins sorrow us, families fail us
or sickness suffers us,
what do we do, whom can we turn to
when burdened with cares?

Our Lord hears all prayers as He truly is the only One,
Christ Jesus, God's beloved Son,
so cast all cares on Him, He will help with problems and pain,
when we faithfully call on His Name.
God lovingly holds us in the palm of His hand,
as on His promises we stand.

SEASONS OF LIFE

We all face many different seasons;
they may be a brief time of gladness
or a long duration of sadness.
Sometimes there doesn't seem to be
any rhyme nor reason for a season.
These periods of time can be age-related,
due to relocations or job challenges
or to the loss of loved ones or friends.
Seasons may begin as interests change
or as our spiritual quest inspires us.

As we struggle to accept and adjust
to these always shifting seasons,
do we lean on God to help us,
to guide, to protect and to provide,
not doubting, but trusting His timing?
Our Great Comforter, the Holy Spirit
will help us through each and every day,
so that by Jesus' grace, we can live
abundantly, effectively and joyfully.
Praise God for all our seasons of life!

FOR ALL THE FAITHFUL

No earthly palace could ever compare;
Heaven is the home for us He'll prepare.

The sweetest welcome we shall surely share
as Christ the King calls us by name.

There'll be no more poverty or pain,
death or sorrow, sin, guilt or shame.

In His glory and power, we shall be resurrected
to reign with Christ forever, immortal and perfected.

FEARING DEATH

We fear losing control and we fear the unknown;
we fear dying and we fear death.

Too much left undone and too much left unspoken.
What legacy do we leave? Did we do our very best?

"Fear not!" the Bible declares as Jesus tells of a Heavenly eternity
for all who believe and love Him; our Saviour lives, so shall we.

Rejoice in His promises as nothing can separate us from Him;
we are His children forever. Fear not! Trust Him!

GRIEVING

Many of our loved ones, both family and friends,
have passed away from this earthly life.

Grief has different stages that we need to travel,
mourning for lost loves, shattered dreams and hearts.

All we may be left with are closets of clothes,
a desk of stacked papers and an empty place.

We cry out in pain to wash the ache away,
as tears are God's gift to cope with our loss.

We need to have hope for those we prayed over,
for their salvation, but we never knew for sure.

For those saved, we can thank our Heavenly Father
that they are Home with Him; no more tears or suffering.

Psalm 30:5 (TNIV)
"Weeping may remain for a night, but rejoicing comes in the morning."

LIFE AFTER GRIEF

Life can often be short
and sometimes very tragic.
We don't know the future,
and we don't know
the relationship between things
and we often don't know
the why of these terrible events.

We do know that our God
is always present and all-knowing,
nothing catches Him by surprise.
So we can be confident
that in everything,
even in senseless tragedies,
He is working for our good.

God, alone, can and will, turn
our tragedies to triumphs,
our defeat to victory,
and our pain to glory.
We stand on the rock of Christ,
Who lived, died and rose again
and is forever with us.

Our life is a fraction of eternity;
death is a transition in living
for those who love and serve Jesus.
We came from our Creator God
and we go back to Him in Heaven.
Nothing can separate us from
the loving arms of our Father.

IN MY FATHER'S HOUSE

Dear ones, the older I become,
the more I think about eternity.

When I shed this earthly shell
my hope is that none will grieve
as I've been welcomed to a perfect home,
prepared for me by our Creator God,
as He promised because He first loved me.

I believe that I came from God and
I believe that I'm going back to Him;
here I will meet the King of Kings,
my Saviour, face to face and I shall remain
in His loving presence forever and ever.

Heaven is a place of spectacular beauty.
a huge, magnificent, walled and gated City,
of transparent gold and precious stones,
without the need of a sun or moon
as Heaven is always lighted by God's glory.

In this dazzling Holy Paradise
we will be praising Him and rejoicing
with a great multitude of angels.
and of saints and of prophets of old,
in perfect worship and in service.

Oh, what a joyous homecoming
as we will also worship Him
with our loved ones -- family and friends,
who have lived and died trusting
in Jesus Christ as their Saviour and Lord.

Here God will wipe away all tears,
the scars of sins and stains of shame;
no more death or grieving
or crying or pain, for our bodies
are now new, perfect and glorified.

Our Heavenly Home is debt-free
because our Saviour Jesus paid for it all
by His cruel cross and miracle resurrection,
it can never perish, spoil or fade,
our forever and flawless dream home.

God, our Heavenly Father, invites us
to accept His important invitation,
to sincerely repent of all sin,
to believe in Jesus as our Saviour
and then to obediently follow Him.

Then we can live with Him in eternity;
it is a choice we all must make.

INSPIRATION POEMS

FROM FEAR TO FREEDOM
SHEPHERDS AND DISCIPLES

Shepherds – Before and after Bethlehem
While humble shepherds watched alone
a radiance poured down around them
as they pastured their flocks far from home.
An angel heralded a birth divine
which terrified them so they couldn't speak
as they heard the angel's prophetic sign.

Then a heavenly host filled all the earth,
glorifying God for His Son, Jesus' birth.

Finding the stable these shepherds saw
a Baby wrapped in swaddling clothes
in a manger bed of fresh, sweet straw.
After wondrously worshipping this Baby dear
with joyful hearts they spread the Good News
far and wide to all who would hear.

Disciples – Before and after Pentecost
Behind locked doors His disciples hid in fear;
they had witnessed the crucifixion, resurrection
and ascension of their Master dear.
Two angels proclaimed Christ's life divine,
instructing them to quickly return
to the Hoy City for the promised sign.

In Jerusalem many gathered to pray
as they grew in number day by day.

When a violent wind roared through,
fingers of fire touched each one
and they spoke other tongues true.
The Holy Spirit removed all their fear,

with joyful hearts they spread the Good News
far and wide to all who would hear.

– –

Will we trust His Spirit to remove our fear
and with joyful hearts spread the Good News
far and wide to all who would hear?

BELOVED ONE

You are unique and priceless
as God's workmanship.
You were deliberately planned
and wonderfully made.
You were lovingly placed
on this earth by Him.
Jesus is gently knocking
at the door of your heart.
Will you now open wide
your whole life to Him?
Believe the Bible's Good News
that for all your sins,
Christ was crucified and buried
but God raised Him from the grave.
He is the resurrection and the life
through Whom you can be saved
Will you praise and thank Him,
love, follow and obey Him?
Jesus Christ is the Way, the Truth
and everlasting Life for believers.

He is Lord of all!

HIS FAITHFULNESS

We thank You Lord, our God and Saviour

for Your faithfulness that never fails.

Guide us in all we are to do and to say,

help us to meet our problems of each day.

Whatever challenges we each must face,

You promise us Your strength and grace.

Help us to turn to You, Who reigns above

always rejoicing in Your endless love.

When each of our days comes to an end,

we thank You for being our Father and Friend.

We thank You Lord, our God and Saviour

for Your faithfulness that never fails.

MIRACLE MAKER

Near His home, in Cana, was the first miracle sign

as Jesus turned well water into wedding feast wine.

Many miracles followed as the dead were raised,

the lame walked, the sick were healed,

the blind could see, the deaf talked,

the nets were filled and the possessed were freed.

Jesus walked this earth after rising from the grave,

then sent His Holy Spirit for our souls to save.

Miracle Maker indeed!

OUR MASTER'S BOOK

The Holy Bible is not in error;

Sacred Scripture lives forever.

Today many treat the Bible

as if it were uninspired,

unreliable, untrue and unimportant.

Our society tries to destroy it

as they dilute, deny, despise,

defy and disobey God's Word.

But Scripture sanctifies us,

is a safeguard from sin and

a shield from satanic forces,

enabling us to be faithful to our Rock,

to worship Him, to do His work,

to witness to others and to watch.

Jesus is coming again!!

The Holy Bible is not in error;

Sacred Scripture lives forever.

DEEPER IN AND HIGHER UP

Prayer is the key to God's heart
and Jesus Christ is the door of
God's abundant grace and mercy.

Through prayer, God invites us
to go deeper in and higher up.
Thus prayer is a catalyst
of transforming powers
for freedom from self-sins,
freedom to minister to others,
and to give joyfully and freely
our time, talents and treasures.

In prayer we can experience
deeper intimacy with God.
We are blessed with new graces
as we cast all our cares on Him.
We can release families and friends,
our hopes, dreams, our future,
our enemies, anger and problems.
We develop new hope in God
as we surrender all in prayer
and go deeper in and higher up.

Prayer is the key to God's heart
and Jesus Christ is the door of
God's abundant grace and mercy.

LIVING FOR HIM

Live for God today,
life is really so short.

Our goals will disappoint us
if we leave God out.
Hold all your plans loosely,
put God's desires first.
Our future is in His hands,
commit your life to His control.
Humble yourself before Him,
love, trust, serve and obey Him.
God deserves first place
in every area of our lives.

Live for God today,
life is really so short.

HIS BOUQUET

We all are flowers in God's garden
of many different shades and hue.

When we display an inner beauty
we gladden hearts of all who view.

As fragrant perfumes spiral and rise
do we lift our pleasing prayers to God?

Do we really try attracting others
to the sweetest story ever told?

We know someday our bloom of life
must wilt and wither away, but

In God's Heaven we shall always be
part of His glorious bouquet.

HERE COMES SPRING

March winds so often blow

with rain, sleet or even snow.

Biting cold will soon be gone,

and returning birds sing their song.

Tender buds on trees are seen

as brown grass gives way to green.

Time again to grieve Jesus' crucifixion

and then to celebrate His resurrection.

He conquered death, Satan and all sin

in a battle only Jesus Christ could win.

Though Spring brings to earth life anew,

Jesus offers salvation to me and to you.

A FALLEN RACE IN A
FALLEN PLACE

We are a fallen people living in fallen times
as our sinful society commits terrible crimes.
Demonic forces abound and are Satan's strategies
of deception and discord, plaguing us with tragedies.
We worship earthly pursuits of possessions and pleasures,
instead we must freely give of our talents and treasures.

God tries all of us with clouds of daily testing,
but no matter how troubling, He showers us with blessing.
When we are tried and tested, do we remain true?
are our prayers praiseful, does our love shine through?
To lead upright godly lives, pray for courage and conviction,
to battle society's evils as we pray for His protection.

Only the love of Jesus Christ redeems this fallen race;
only the promise of Heaven redeems this fallen place.

WHO OR WHAT?

Who or what is our first love?
Is it our Heavenly Father throned above
with Jesus, Lord of lords and King of kings?
or is it family, friends, fame or material things?

Who or what is our life's passion,
to be liked, well-groomed or in fashion?
How much time do we spend daily with Him
in Bible study, prayer and meditation?

Do we strive to serve Him and to obey;
do we share the Good News each day?
Only Jesus knows what is in our soul;
only He forgives our sins and makes us whole.

So we must trust Him and not delay;
seek His face and run to Him today.
Our first love and passion Jesus will be
as He prepares our Home for all eternity.

IMPRISONED OR LIBERATED

Imprisoned
We become prisoners of the darkness
when held captive by unrepentant sin.
Our prison bars of hate and prejudice
can help Satan to chain us in.
We may be gossiping or cursing;
addictions and dishonesty within reside.
We are consumed with anger and unforgiving
or faithlessness because of sinful pride.

Liberated
Be assured that each act of obedience
shows we serve the One we adore,
Who can break down our prison walls
so we can walk out through its door.
We will be released to live each day
in the true light of God's freedom.
Loving, caring for and sharing with all
in our journey to His eternal Kingdom.

FROM ACORN TO OAK

An oak tree hides out in each small acorn.
Only when an acorn dies to self and is
nurtured in good soil, can it be reborn
into a mighty oak as its branches open wide
sheltering birds and beings, giving solace to the weary;
its deep, anchored roots protecting the earth.

Only when we die to self and are anchored in Christ,
can we be spiritually reborn to become a mighty warrior.
Our arms now open wide, sheltering the lost, the hurting,
protecting the young and fragile. Christ enables us to withstand
life's droughts and storms, totally secure in His awesome love.
For all of us, an acorn of hope can grow into an oak of faith.

KINGDOM'S DOOR

Doors can be closed to keep out danger, darkness and fear,
or
door can be opened to welcome people, sunshine and fresh air.

Jesus stands at the door of our hearts and knocks, ready to join with us,
so
when we invite Him in He will enter and stay, never to leave or forsake us.

His desire is to be Lord of our life and home, when we accept Him as Saviour,
then
let us open wide our hearts so that He is our everlasting Lord,
all the time, wherever we are.

DEAREST JESUS

Every time, dear Lord, when Your name,
is so often profaned, I feel such pain.

Why must Your name be used to curse
all the shortcomings of this universe?

Profaners try to re-nail Your hands and feet
as Satan's victory seems so very sweet.

How can we meet You face to face
and hope to live in Your dwelling place?

Open all our hearts to only proclaim
in prayer and praise, Your Holy name.

GOD IS ABSOLUTE

Our Heavenly Father
is a God of love, mercy and grace.
Our Lord is a mighty God,
Creator of this awesome universe.
Our Fortress is all-powerful,
all-knowing and always present.
He is not a God of murder and mayhem
as all his children are precious to Him.
He is a God of supreme justice
and he abhors all evil and sin.

Believe it or not, but some day,
after our earthly life is over,
each of us must stand before Him
to either receive our eternal reward
or to be separated from Him forever.
Choose now to love and follow Him
and to believe His wonderful promise
to live eternally in His heavenly home
with Jesus and His faithful followers,
whom He has forgiven and redeemed.

POCKETS

From time to time
we need to empty clean
the pockets of our life.
Turn them inside out
to shake loose all
the hurts, grudges and shame.
Help us Lord to look to You
to stop crying the blues
but to give You praiseful thanks.

Help us Lord to forgive
all those who have wronged us
as You forgive all our wrongs.
When we are then clothed
with Your righteousness,
we are cleansed and made whole.
From time to time, Lord,
help us to empty clean
the pockets of our life.

GOD'S SIGNATURE

God's signature is imprinted on us
from our birth until our death.
It is inconceivable that our birth
could just happen by chance.

God is the author of all creation
in this entire awesome universe
His amazing power is beyond
all our wildest imaginations.

There are no boundaries ever
to His magnificent greatness.
Let us open our hearts and our eyes
to His beauty and His splendor.

Then we need to praise, worship and
give Him honour and thanks for
Who He is, for all He has done and
for our Risen Saviour Jesus,
His one and only begotten Son.

ESTHER

From a little orphan girl to a lovely young queen,
while living in luxury and secluded in safety,
Esther loved the Lord.

When the lives of her people were in such great peril,
she stepped up and stood in the gap,
Esther served the Lord.

Open, available and ready for God to use her,
she humbled herself before her kin and king,
Esther obeyed the Lord.

Facing a frightful future, she prayed and planned.
Her courage is today both honoured and celebrated,
Esther trusted the Lord.

Although we may never be a hero or heroine,
we can love, serve, obey and trust the Lord
as Esther did long ago.

PETER, PAUL AND MARY

PETER

He was a simple fisher and a family man
who loved the sea and his homeland.
He denied Christ when he should've defended;
he ran away from Him when he should've stayed.
Peter returned, confessed and repented.
He was restored to love by Christ's resurrection.
We, too, can be a rock in our church's foundation.

Will we be faithful in His service?
Will we be repentant like Peter?

PAUL

He tried to destroy the Christians he hated
but in a blinding vision a new person was created.
He traveled, healed and taught both Gentiles and Jews;
he suffered much as he spread the Good News.
Paul preached salvation through Christ's grace.
Like the perpetual thorn troubling Paul's side,
we are pierced by people, problems and pride.

Will we be faithful in His service?
Will we be committed like Paul?

MARY

She was young, poor, pregnant and betrothed;
she suffered much pain from those she loved.
From His divine birth in the town of Bethlehem
until His earthly death outside of Jerusalem,
Mary lovingly served the Son of God.
From the moment when our faith first came alive
to our final hours of our earthly life,

Will we be faithful in His service?
Will we be obedient like Mary?

CAPTURED BY CHRIST

Saul, a trained and true Pharisee,
persecuted Christians without mercy
as he believed that this new religion
was so dangerous to his Jewish faith.
As Saul set out to capture Christians
and bring them back to Jerusalem,
he was stopped cold in his tracks
and captured by the Risen Christ.

When Saul personally met the Lord Jesus
on the highway to Damascus,
he was traumatically transformed
from a frenzied persecutor of Christians
to a joyful, zealous preacher for Christ.
Immediately he was born again,
soon to be called by his Latin name, Paul,
and as a pioneer missionary, he travelled
throughout the pagan Roman Empire.

He proclaimed salvation by God's grace
through faith in Jesus, with love
as the core of all Christian life.
Paul's many letters of instructions,
written to widely scattered churches,
addressed their specific problems
and most of these epistles later formed
an integral part of the New Testament.

Although he suffered from the dangers of
shipwrecks, imprisonments and beatings,
even put to death for his belief in Christ,

in his words, he "fought the good fight"
and he, indeed, had "finished the race".*
For all, Paul is a beacon and a model,
a true hero of our Christian faith
as he is forever captured by Christ.

Are we, like Paul, a captive, too?

*2 Timothy 4:7 (TNIV)

ETERNITY

When you close your eyes for the very last time
and take your final breath and your spirit-soul leaves
this earthly life behind, where will you spend eternity?

Are you prepared to stand before the Lord Jesus Christ
on His Great Judgment Throne?
Is your name recorded in the Lamb's Book of Life?

Will you be joyously joining God's angels, His saints and
all His faithful servants, welcomed into Heaven above,
or be separated forever from His presence, grace and love?

Have you refused to accept God's way of salvation through
His Son's sacrificial death?
Will you be cast into an everlasting infernal state?

So believe and don't wait, for now is the time,
before it's too late to turn from all sin,
ask Christ into your heart, repent, love and obey Him.
Chose now, for you, what will it be,
Heaven or hell for all eternity?

NOTES:

NOTES:

NOTES:

NOTES:

NOTES:

NOTES:

NOTES:

Notes:

NOTES:

NOTES:

NOTES:

NOTES:

CPSIA information can be obtained at www.ICGtesting.com
Printed in the USA
238280LV00002B/2/P

9 781462 705085